Field Notes

Field Notes

Walking the Territory

Maxim Peter Griffin

unbound

First published in 2022

Unbound
Level 1, Devonshire House, One Mayfair Place, London W1J 8AJ
www.unbound.com
All rights reserved

Text design by PDQ Digital Media Solutions Ltd.

A CIP record for this book is available from the British Library

ISBN 978-1-80018-118-2 (hardback)
ISBN 978-1-80018-119-9 (ebook)

Printed in Slovenia by DZS

1 3 5 7 9 8 6 4 2

MIX
Paper from
responsible sources
FSC
www.fsc.org FSC® C106600

Look, a mirage, like a round rim, a strange
Wizard's masterpiece about us:
An old line that's not there,
A boundary that never ends

Dewi Emrys (trans. Anthony Conran)

ONWARD

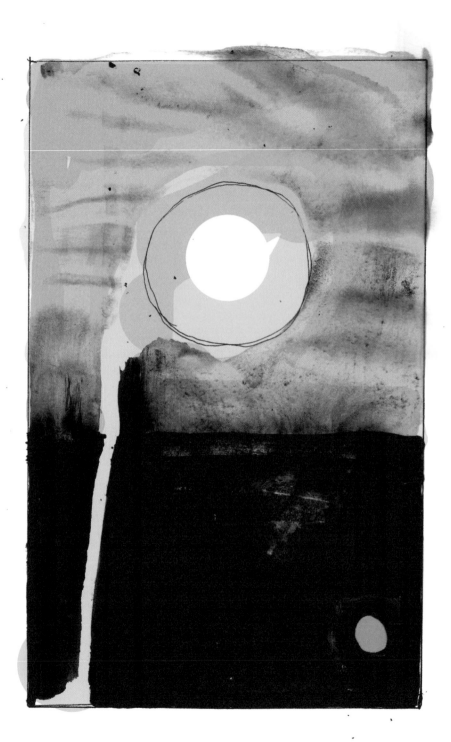

October

13/10 – first light over Lincolnshire – the woods to the west of town are approaching the best bit of the year – mist on the bypass, an orange bread truck passing through – tiny spiders eating each other on the stile and the barbed wire.

14/10 – a parcel of hagstones from Kent – painting for the geologist.

22/10 – making a drawing, gunmetal over the satellite villages, a 9B pencil – kicking the boot off – Brasher from Oxfam – £4 – lasted eight months and a hundred night shifts – the cut's infected – nothing to be done, clean it with some spit, get moving – the sun is coming – muntjac in the creeks retreating toward the dykes – look – east – Turner was right.

31/10 – got a trudge on – a couple of nights off – top of the Wolds – copse for pheasants, wired off – old boots starting to let the damp in – still a bit mild for coat – walking cold is best – red nettles – up at the track on the edge of the Bluestone Heath Road – prowling for signs of glacial erratic action.

–

Look – the shape of a landscape, the depth of it – the weight of low hills – the arc of the sun over the outer, Hanseatic east – over Triton Knoll, Doggerland, Skegness – afternoon wheels into evening – the mustering of geese toward the marshland winterings – skein after skein until night and after – 40,000 pink-footed – full Beefheart voice over the spirit levels.

Look – the peak of autumn – leaning on a five-bar, sore, weary – Paul Nash prospect over the low sun – a black field, a back road, enhancing the landscape with mid-period Can – pathfunk – a panorama over the

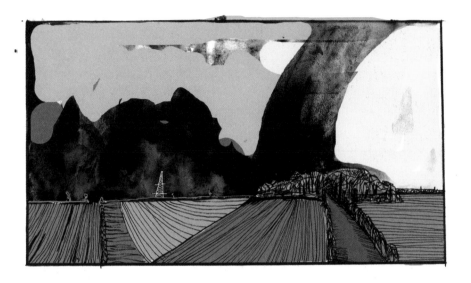

edge of the North Sea, the outer east and west where the sun ends – chalk and flint underearth – in the limb junction of the oak is a green triangle sign – on the map the triangle is red – there's a church down the hill but hardly a village – the Shell Guide missed it.

This is the territory – Doggerland and the Chinook-blasted ranges – intertidal marshland, psychic care homes, the Humber jaw and those places where the tumuli are.

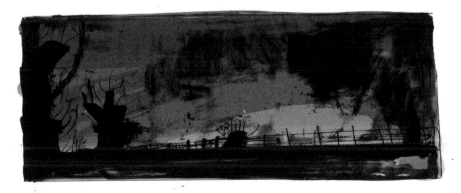

Look – B road spines the hills south to north – Scheduled Monument/ Ancient Track, shortcut, corpse road, border – they pulled most of the radar station down and the tropospheric scatter dishes heard naught but the scamper of trespassers and field mice – just that big sky – a system of weathers comes up from the Wash – the late low shine hits the beams of the mast sideways.

West to Trent – an atomic blush, the Midlands out there – day wheels west/Sirius arrives – good.

Look – a breath of rain from after the boundary – mixed thicket, mainly deciduous, black branches – old parish lines being followed – demarcations blurred by weather – a church with no tower, no bell, Pevsner did not visit.

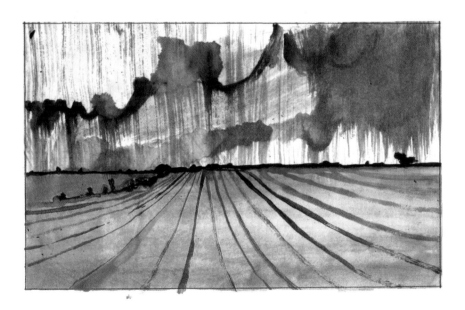

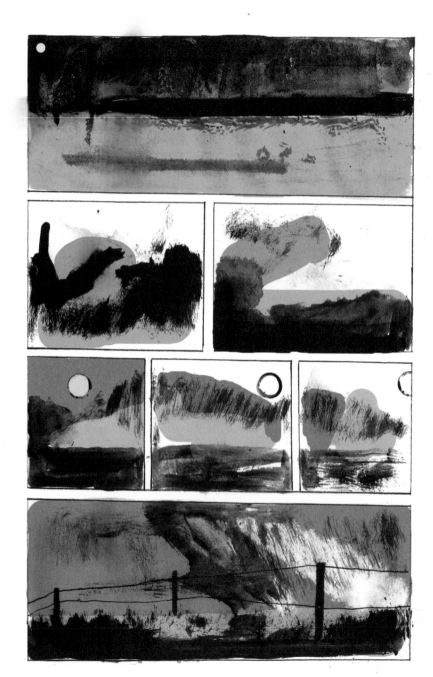

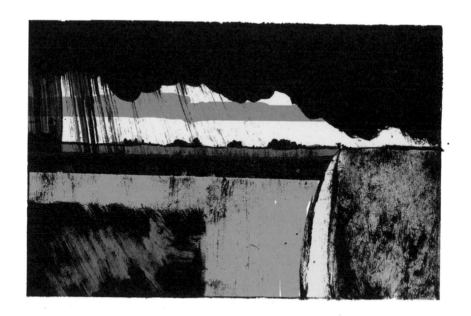

A black dog huffing at the gate of a semi-detached – look – draw – repeat – just get it down, hit and run – remember seeing Hockney in a layby, remember Schwitters at Ambleside, remember Johnny Nice.

Look – draw – repeat – crosses for crows, scribbling the canopy.

The squall of it, the weight –

In the geometry of the field, headlights pick up the crush of chalk on the surface – bigger lumps turned to the edge – stones brought here during the last invasion of the ice – granite pulled out from another place in another time from rivers in the north that have no names in memory. These pebbles are best for breaking flint.

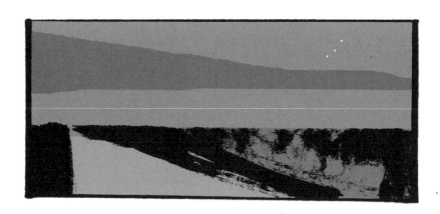

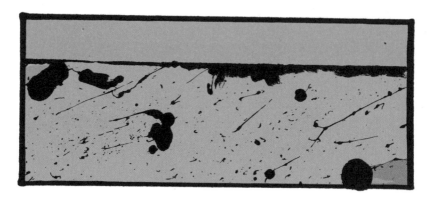

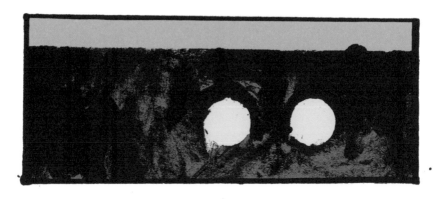

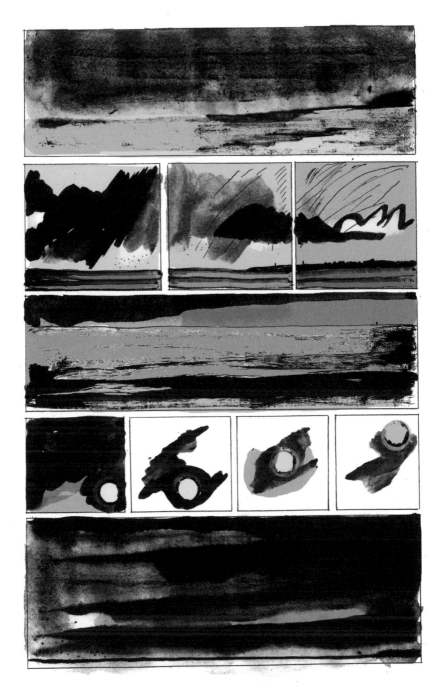

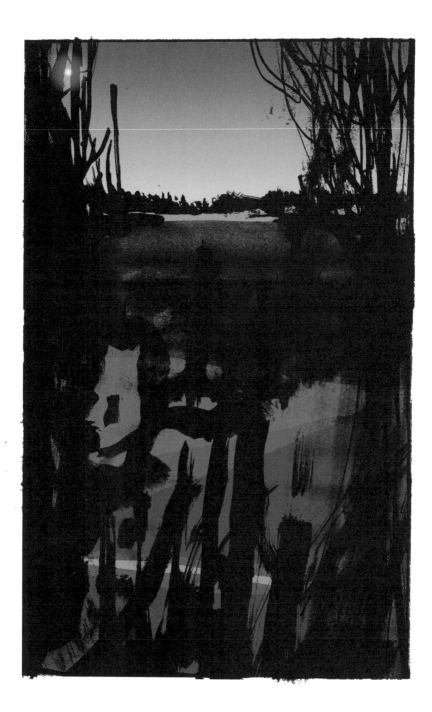

November

2/11 – walk to night shift – still the odd bat about – woodlice on the concrete bridge – a man with a carrier bag of tins, one on the go.

3/11 – walk to night shift – clear enough for Mars – an ambulance at the junction – bins out, a gate bolt driven home.

4/11 – walk to night shift – a good dog – branches around streetlight – bright capillaries – fast clouds – later – a halo around the moon lasting hours – the ISS passing over, brilliant and steady at three.

5/11 – woke at noon – walked to Calcethorpe – fell over – cooked bacon as night arrived – limping with a deserter's gait.

–

Keep heading east – follow the water – the sound of low fighters.

After the outmarsh, dune territory from Mabo to Clee – pillbox in thorns, bungalow in brambles – warrens, lonesome spots.

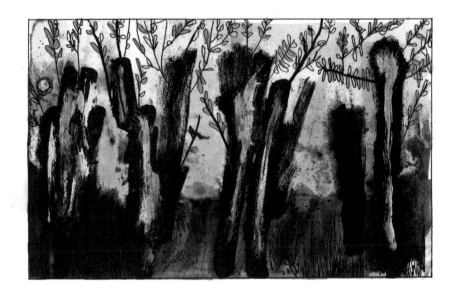

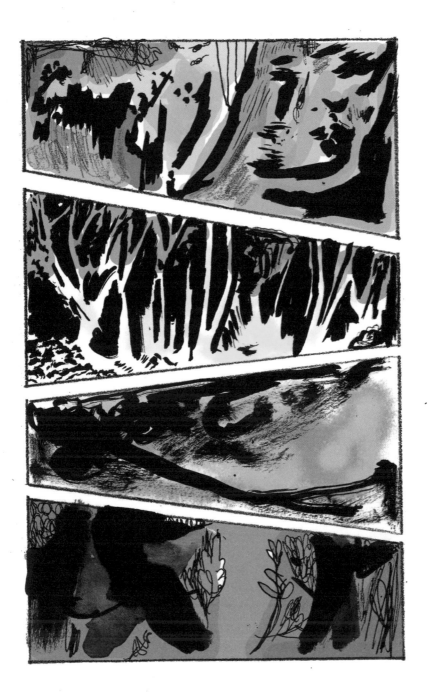

Look – a brown sign – PARADISE – NO CARAVANS NO CAMPING – beyond the outflow works and along a rubble track – a cluster of smaller vessels at angle with the silt – waders with curled beaks and straw legs go about their business in the intertidal reaches – the boat *Boy Henry* does not move, an orange pot marker taps the hull – the month of the Great Eau, the edge of the sea.

To the south – hidden creeks and marshland – tricky going but navigable on foot if you are in a mind for mud and uncertainty, for crabs and ancient ordnance.

To the north – artificial lakes, static caravans – empty for winter – a chippy in there somewhere too – it was quite good. Car-boot sales in the summer. Tank traps in the scrub – never seen action – curlew and geese – waders/avocets.

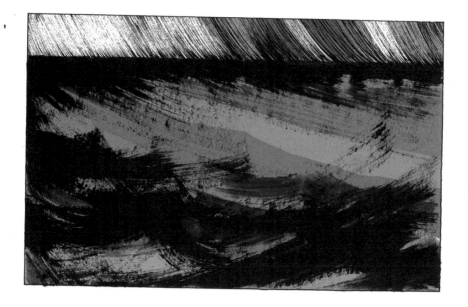

It was busier here once – Edward I launched infantry from here to the Scottish Wars – Fairfax was here – Tennyson had a house close by.

The boy John Franklin walked here to watch the ships and dream of adventure. They say he ate his shoes before turning to ice with the *Terror* and the *Erebus* somewhere in the Northwest Passage.

Look – vapour trails heading west – Chicago to Munich, JFK to Frankfurt – then a layover perhaps, before further journeys – curved air that turns to crystals in the stratosphere.

On. The track leads to a space for cars. The council took the bin away last year – debris – a knotted carrier – dog-shit bags, wet wipes. Best to have a sack ready for such things. A camper van with windscreen blinded but the side door is open. A man with a Midlands accent – Nottinghamshire maybe – talks into a telephone from the reach of a selfie stick. Nod. A side glance at his equipment suggests he has camped the night. A bed roll, a sleeping bag, a stove, a pan, empties.

A spit of dune points to the sea – over – wind-shook marram grass holds the sand together – just. There are rusting things bound in the roots, debris that landed here a long time ago – parts of something mechanical and reinforced concrete – every so often a vehicle is burned here. Chrome and oil after the blaze settling in the tar blackness of the lower dune strata.

From here the coast curls into Humber – so much so that the superstructures of the tankers are given the illusion of sailing on land – sun illuminates bright liveried containers and their drivers – bulk cargo to the Hanseatic ports. Same as it ever was.

The tide is out. Judging by the traces, a 4x4 has been here early doors. Checking the lines – an old fella used to bring crabs and lobsters in and his wife prepared them – weekend mornings – dressed and ready, £3.50 a pair.

Look – strandline – blue rope – plastic shards – yellow bottle (Mountain Dew?) – razor shells – mixed twigs and timber, not new – a spun-iron fixing – bone.

Seal leather, rib elements – sinew remains on knuckles – seal fist – in older days, taken for a relic, perhaps.

Another fighter jet – more feedback than clear engine sound – arcing over the north against the forces of gravity – eight geese make low pass towards the sea.

Strandline – a child's summer shoe – *Frozen*. Always *Frozen*.

Away from the dunes now – over channels of mud to the looser stuff – the aeolian process in full swing – a billion individual sine waves.

Out now, where the inlet becomes the sea. Low tide lowest. Here the wreck of the *Try* – sank once with five lives 1882, here – salvaged and here set sail again, here – sank again 1890 – all lost – a whole family drowned – the stuff of ballads – they're all buried in Louth up on Julian's Bower.

A drawing cannot capture the mirage of this place – ink cannot conjure it – perhaps it is best to cut a line through the sand.

The tide returning – shipping in the jaws of Humber wait their turn to dock at Hull or Immingham or Goole – the light from Spurn in rhythm with those of the distant wind farms – shine carried on an incoming fog.

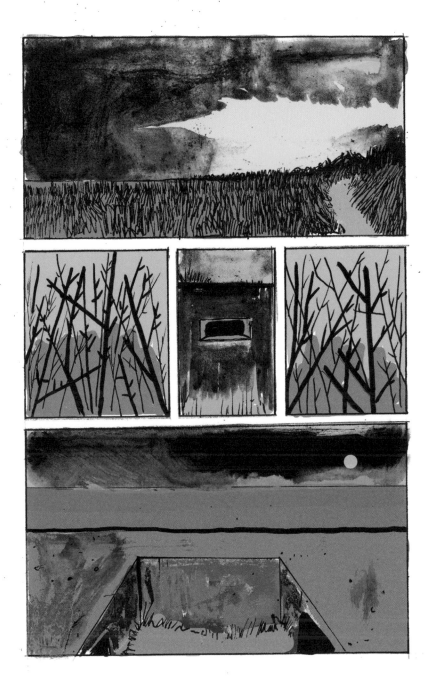

The flag is up over the range – not dark yet.

Hum off the coast-road tarmac – colder as the daylight shifts west a gear – burr of the sea – pistons deep in the bellies of tankers, ticking over.

Kachunk... kachunk... kachunk...

Nightingale, jackdaw – slo-mo.

A heartbeat – a breath – and through that pulse – helicopters – attack craft from Norfolk bases come to light up dummy jeeps and dummy flatbeds with bursts of tracer fire that bounce away into the jaws of Humber – they turn the night phosphorus.

Look – the dormant forts, Haile and Bull Sand, lit by buoys and beacons from waiting pilot boats – the concrete gun decks have been redundant since the war and are, on occasion, proposed for development – must be a staging post for gulls, judging by the flecktarn of shit.

Radar pulse – beacon flash – hit confirmed – look – all the colour but the sound is far away.

Amber upshine from Grimsby/Cleethorpes/Fitties/Tetney Lock – the burr of settlement noises – somewhere in the fields between here and there a dog barks once, the movement of a walker – there's a path that divides the tide zone and the edge of farmland – pipes cross it from refineries, a sliver-edged pumping station – two small pillboxes with numbers painted on them – 1 + 3.

A gravel place where cars pull in at the end of an agricultural road – casual debris, tissue and coffee cup, a blue nitrile glove. The map names this place Horseshoe Point. Bad place. Sad place. Not so long ago, three boys were lost to the sea here – a memory of it, that summer,

Euro '96, a girl from the number 14 school bus who knew them.

Cars park up at night, headlights full beam over the creeks and tide, and things float – plank, bucket, shoe, bone, stick, brick and black oily matter with the sticky feathers and dread.

Polystyrene boxing – yellow battered crate, partial lettering – fragments of material – something from a beak – the yellow dagger of a gull beak – a fridge – the door of a playhouse – a shoe – timber, blue rope – a can – Pepsi, old ring-pull.

There is always wind, always movement – even in the quietest second the landscape is accelerating – malleable to the elements – soon the stomachs of Heinkels will manifest from the water impaled on fossilised oaks, a Beaufighter in the sandbanks.

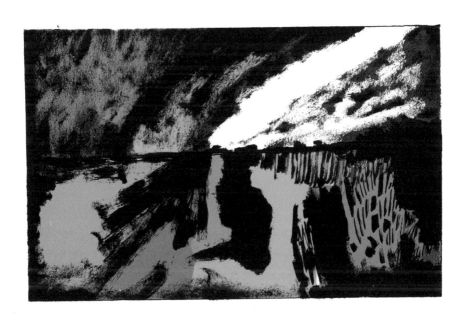

In myriad grasses and thorns, geese and other fowl – black ducks in invasion-code feathering – tiny land birds that move in mysterious clouds/the smoke of a musket – citadels of rabbits more fierce and complex than anything on Watership – the great warren under Nook – a great many bones are always available.

Fox teeth, barbed wire – a tiny skull on a fence post – the platform of an ack-ack gun – it gets weird after dark – depends who you ask.

Men used to come in the night from Midlands cities to race down hares with lamps and dogs, and the police turn a blind eye to camper vans.

A man and a woman and a black dog navigate the warren and head onto the low path by the thorns that leads to where the *Rimac* sank.

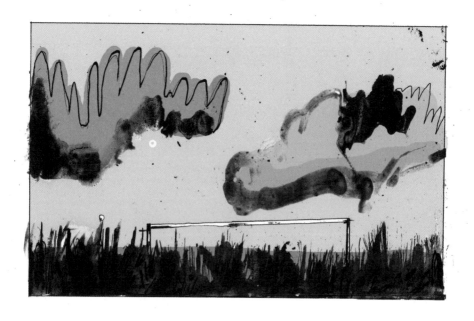

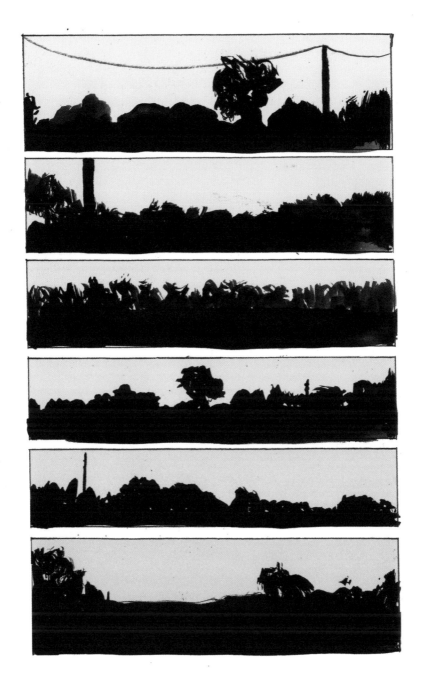

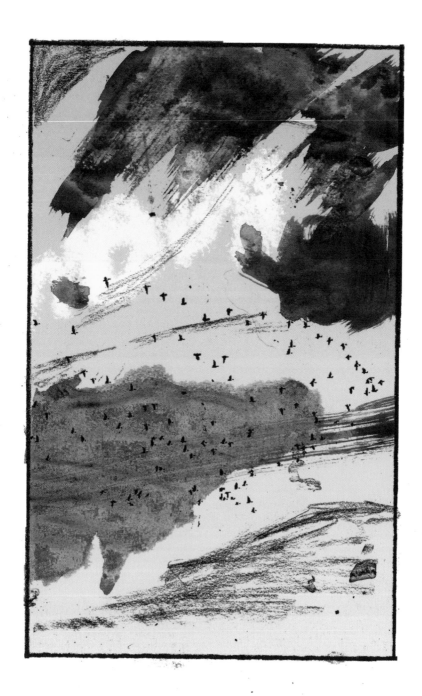

December

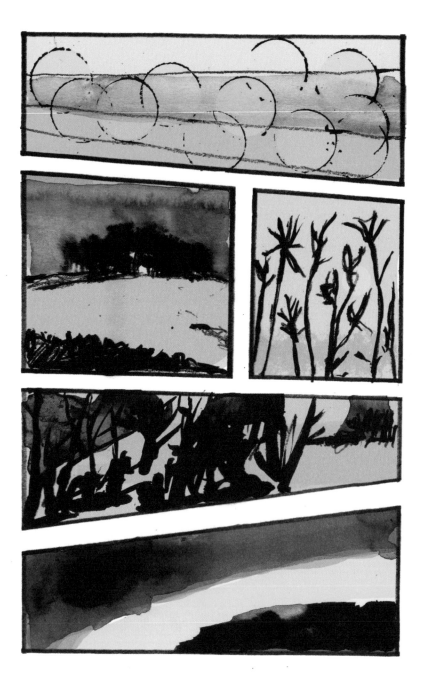

1/12 – making a drawing of the hills to the west – Humbrol, black ink, pens – glue on the boots is holding well – making way down the Grayfleet – all the local ditches have special names – Seven Dykes Eau, the Harrow Sea – starlings on it today.

3/12 – first frost of remark – across the scrubby patch with dog – winter puddles with a skin of ice – holding a shard up as a lens – the first edge of the sun.

17/12 – walk to night shift – trees up in the big houses have a certain rivalry – two kids, one bike, handlebars – a green skip with most of a bed in it – the call and response of Christmas lights in Terry Riley sequence.

24/12 – walk to night shift – running on fumes, riding the hours out, thinking of Raymond Briggs/Hans Gruber.

–

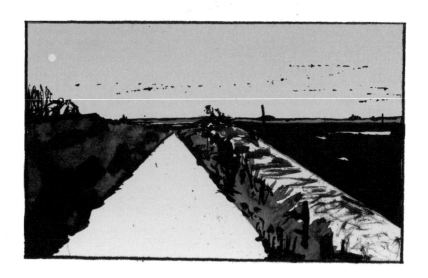

Look – out there under the roof of the North Sea – Doggerland.

All this from here to the next land east was a green territory – delta, marshland, hill country – not long ago – 10,000 years perhaps, since the last glacial maximum – no time at all under the arc of the stars – all those Mesolithics lived out there, after the ice, worked the game – red deer, proto-ox, mammoth – bone-tipped lances ready. From here to the wind farms there were chalk cliffs, then clay, and clay is where forests grew – pine and birch, mixed deciduous – birdsong under the sea.

But nothing is fixed. Change is certain. The ocean will have us all – good.

Water came creeping in – perhaps there were attempts at management – ditches and proto dykes, maybe they worked – for a while.

Marsh became swamp became lake became delta became impassable became unliveable until the uncertain borders joined with whatever those families called the saltwaters that came. The floods were beyond imagining.

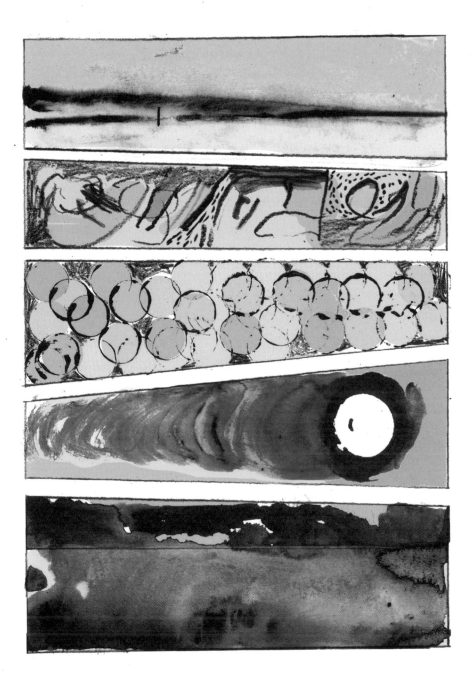

Imagine the midges. Smaller mammals living off the festering marrow of red deer cadaver.

People moved with the food – same as it ever was – moved to the upland, where meat could be managed in the valleys the ice left behind.

A population in slow migration – 6,000 years ago – in the folk memory of the ghost mammoth.

Fishing boats on occasion bring evidence of these lives – there are footprints of past children in the mud – beyond the amusements, beyond Mablethorpe, there are petrified forests – birch stumps in the clay.

Look – now, or near enough – the last hundred years – another migrant population heading the other way – Golden Sands, bingo, an entertainment, a cheap week, somewhere to retire, to wait on death. This is not a bad thing. Mablethorpe in high summer thrall is, in its own odd way, glorious. There was one night, June in the millennium year – 10,000 gathered to give witness as illuminations were switched on by the Chuckle Brothers – the call and response, the height of their powers

– to me, to you

– to me, to you.

And the carnival queen was there in flowers and white, gifted to them and all 10,000 faced toward Doggerland.

Barry and Paul offered their touch as faith healers would.

To me.

To you.

A two-headed god.

And the sun fell and rippling stars hung from the amusements and the chips stank all vinegar and salt and it was beautiful.

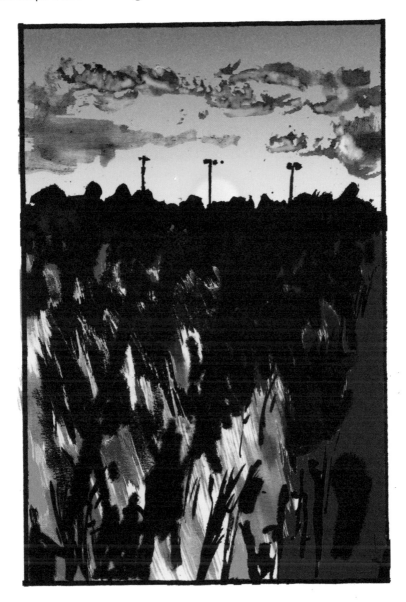

January

1/1 – making marks on paper – little scratches for jackdaws – two older ramblers look on the work with dismay – over Jack's Furze, a red kite – Listening to Conny Plank/Moebius – *Rastakraut Pasta* is perfect walking music – clear light, everything the colour and pattern of Iron Age jewellery.

3/1 – Red Hill – gets all the weathers – high enough for these parts to be able to witness the glimmer and shine of the Wash, to see the cathedral – heel bleeding, eight miles downhill homeward – took a scramble along the Withcall line – thorns and dead badgers.

7/1 – up in the woods – the den has been trashed – lasted four winters – fuckers.

13/1 – east of the battlefield, a bird hide used as smoking den – just over the ridge, some hippies have made a stone circle to do magic at other hippies – sent images of the folly to a doctor in Scotland.

–

From the edge in – to the hills – eight miles give or take – not far, not long – you can walk it easy enough – on older maps they used the more poetic outmarsh – iron flat, herringboned with ditches and dykes and thin meanders – Great Eau, Lud – big fields – hairline villages that grip the boundaries with names from Dark Age tongue – Somercotes, Manby, Grimoldby, Solaby, Skidbrooke.

Only persons of character can cope in Austen Fen – mixed churches – Methodist, C of E – bits of Victorian bricolage, bits of Saxon gritstone. Big fields heavy on the oilseed – corrugated asbestos sheds – red-brick house in yard, local style, mid-nineteenth-century – away from that, battery hens in low, long battery-hen sheds – you can't hear them because the extractor fans are pumping.

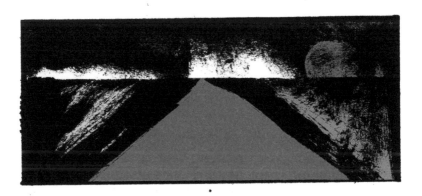

Sign warns CCTV – FARMWATCH with a picture of a beady-eyed scarecrow – a cluster of ash trees – there are a number of machine remains, comfortable in the nettles and flaking to umber in the damp of undergrowth. A blue rope swing that has not been swung on for years.

Look – a lad with bare chest in a crop-spray truck gives a cautious wave.

The sky is the belly of a dreadnaught – lines of razzle-dazzle – high contrast toward Alford – Prussian blue over the North Sea, match strikes of white where the turbines stand.

A static caravan beside a bungalow. Since the school closed, someone keeps a donkey on the playing field. There was a shop. Good stop for maize snacks, Polish lager, two wines for £5.

Always evidence of the wars – memorial, hardstanding, pillbox, Nissen huts in a row – weed-cracked remains of runway, poppy culture – it was, at one point, all runway around here.

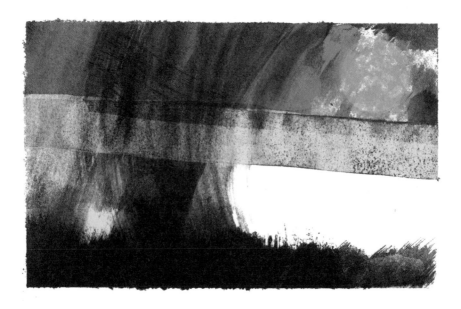

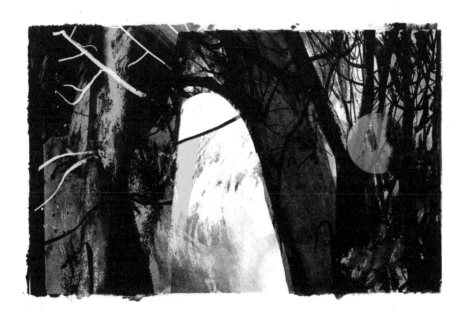

Every so often there is reason to raise union flags for remembering – a green privet with St George bunting before another red bungalow – a faded drawing of a rainbow in the window – an ex-petrol station, pumps dry, circus posters taped to the door.

A village of mainly ex-RAF married quarters with a larger shop, a functioning school, traffic lights. Two streams riddle through earthwork in the middle – DMV? There was a priory around here somewhere – next village over was on *Time Team* twenty-three years back.

After the conquest, all this was inlets and marshland – weird islands, secret places, Tollundscapes, those places where the worship of the Christ filtered through older, more distant gods – a strange culture in the reeds – around the time of Hereward, the Normans built two mottes out here to keep the population under the hoof – forts had to be of wood, all the stone was need for Odo's great church over the hills.

Sign – CAR BOOT EVERY 2ⁿᵈ SUNDAY – NO TRADERS – NO CATERING.

Sign – 3 miles to Historic Market Town – WEDDING FAYRE AT GOLF CLUB (closed) – garden-centre meal offer hoarding SUNDAY ROAST + PUDDING £9.89 (take Mum, then she can look at the fish, touch the azaleas) – home of a bookie, home of a crook – the edge of town always has the most vulgar houses – statuettes on spray-tan brick of big dogs who deserved better.

Look – the head of the first hill is crowned with the halo from roundabout LED illumination. Bollards erected with the equinox sun. Also, big coffee cups/flat mammals.

The local paper reported the sighting of a black panther up here once – bloke in the pub reckoned it was a Shuck. Someone said they saw it near the barrows.

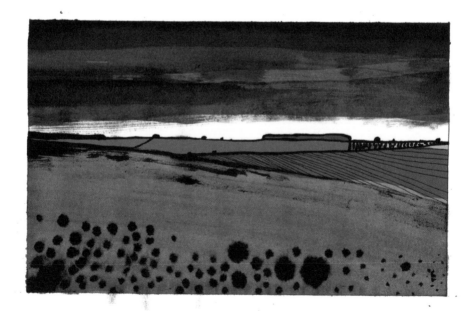

Much was made about the digging of the bypass – not long back – thirty years? – to divert the coaches from coming through the middle of town – mainline the summer migration direct to target – Skeg, Chapel, Ingoldmells – places still trading on the idea of cheap seaside fun – at night they turn weird, sticky – angel tarot, country 'n' western, the ghost of Ken Dodd, happy hours that last a season, huffing spice in a chalet at midnight with a girl from Worksop. Skeg's alright, bit of a pier, groynes, Gibraltar Point – beyond there, the secret way over the marshes and into the winglands of the Wash.

A lorry hisses at the junction by the cross and flowers where the accident happened – dirty stems – older maps name it Hungry Spot – someone planted snowdrops and daffs.

There are methane vents from the old town dump and a phone mast – that house in the pines where Roy Chubby Brown lived occupies the same scarp the barrows do.

Look – there are six in a row and one off a little, in orbit – the Bully Hills – never been dug and rightly so – the farmer goes around them so the grass is old, always pale – Bronze Age and earlier – by the lane is a gibbet decorated with old toys – it is an active place – always has been – a little plastic Smurf fixed to the post with a nail, a few of those mini Boglins superglued to the post.

February

6/2 – painting over the North Sea, choppy out – tankers heading to Immingham, then Goole – shore leave – starlings eat chips in the shadow of the chip golem – on the railings are tied floral tributes – love you, Mum – a mobility scooter trundles along the prom – ghost mammoth shakes off ocean scum and drifts inland – bingo later – angel tarot with buffet – a medium – cancers, messages, Sellotape.

17/2 – walking off the previous night – Hoe Hill is not in any guidebook – weird place with a loaf-shaped summit – doesn't sit right with the rest of the valley – spring of the Lymn, Tennyson territory – there was a girl who lived in the big house, friend of a friend, but that is another story – Norfolk visible again.

18/2 – walk to night shift – the news is full of weirdness – buckle up – approaching the dark hours with Herzog attitude – quick clouds going east at an aggressive tempo – odd stars – the next morning, a heron stands in the Lud.

22/2 – rucksack full of flints from near Grim's Mound – nodes of chert and devil's toenails – some good hags too – one as big as a child's head – listening to Hand of Stabs in a chalk pit, eating a cheese sandwich – pathway to ruined medieval church, scene of night-time runs.

–

The hills aren't much, a post-glacial ripple – from the barrows at Bully Hill till ten miles west, a flow motion of chalk and clay that drops away toward Witham, Trent, the A1 and the world of fen.

Arable for the most part – that *Days of Heaven* shimmer in the summer, all the browns thereafter – Bruegel-style.

Look – tiny settlements in the hills with Viking names – clustering around farms, big houses – a feudal air remains – always the odd field with the scars of earlier occupations, mysterious furrows, domestic earthworks – places that got kicked in by the plague, then the industrial revolution.

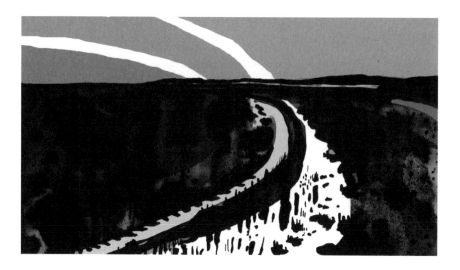

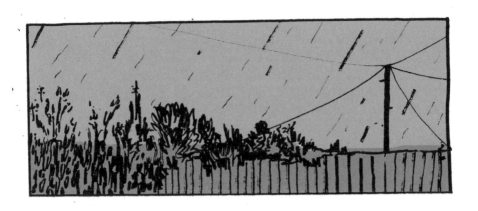

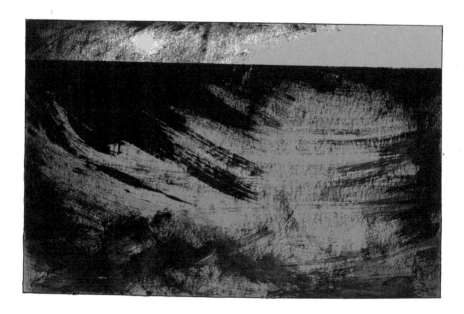

Always a church, no matter the scale of the settlement – empty gothic pews, no regular services, the occasional funeral, the occasional new headstone – red-brick farms on the sites of late-Roman villas – barns fashioned from hangars.

Cromwell made a name for himself on the plateaux – 3,000 horse full tilt back in '43 – the killing didn't stop, an atrocity in every village – memorials to the dead of other wars – pals and bomber crews –

We won't make the runway – pull up, pull up –

Holiday cottages – a couple of Vote Leave signs still in place – sun-faded rainbow drawings in the window of the only post office until Horncastle.

Parch marks in dry fields – humps that don't get ploughed – no digging here.

Stains of activity in dry soil.

Down in the bottom – the wounds of brief railway infrastructure – the engineers laid tracks down the meltwater valleys until they drove straight through the heart of the hills and under the next cluster of barrows, under the radar station.

Look – the mast is deaf now – it used to listen, back in the war – the tropospheric scatter dishes got chopped down years ago, sat on the edge of the hill for two decades, gathering rust – kids used to skate on them and it was a good spot for mushrooms until the scrap value got interesting – the dishes vanished one night – the mast remains – the army still owns it – the mast receives no signal, sends no broadcast – deaf mother pylon of the Wolds.

She looks out full circle.

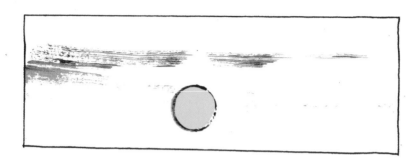

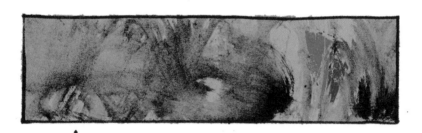

March

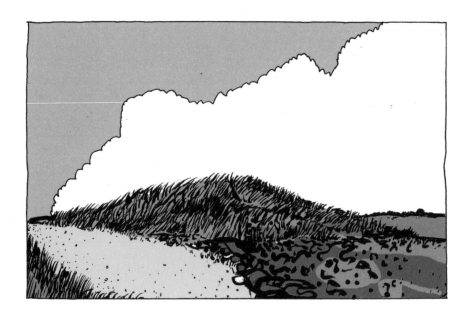

5/3 – a late-winter storm – boots on early and out in it – hard slush – bars of ice in the ruts – a Wehrmacht stove with little fuel tablets – a tin of Prince's Irish Stew eaten with a Chinese spoon, blue and white – it is a feast – iron woods full of deadfall, badger tracks.

19/3 – drawing the sun for Paul Nash and Vincent Van on the edge of the marshes – walking to 'Orgone Accumulator' – Hercules low over the range, Chinooks later – bright tankers off Spurn.

24/3 – made a list – gleaming not gloaming/no moat swimmers – parcel of decent noodles, for the nights – a whale beached near Skeg.

30/3 – landing awkwardly after an enthusiastic stile vault – powerlines north are white enamel letters cut into slate – the electric ley – in a church porch for shelter, signs announce cancelled services.

–

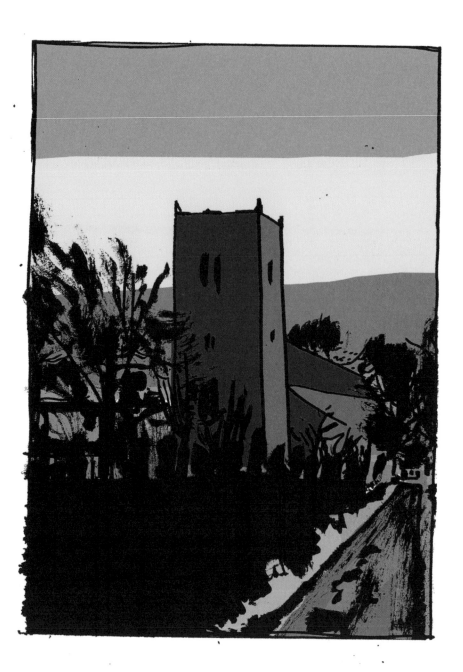

A churchyard, somewhere quiet and away – the recent past – mid-morning. There is a blue van parked in by the lych gate.

Side door open, thermos, bucket, tools, stone. A sack barrow padded with old carpet.

The church is simple, squat – a mesh door over the porch to keep the birds out – fading parish notices. A hagstone hanging from the timbers. Wood that grew before Crécy, that knew the apricity of the Plantagenet sun. Fat iron nail ends in an unlocked door behind which are empty pews, voiceless hymn books and a bell that has not rung for three summers.

Look – an older man and a younger man cut a rectangle of turf clear at the head of the grave. Three inches deep – always imperial – sods laid careful on an old sack – exposed earth is broken up by the blade of a

trowel – a millipede is removed, gently – there you go, mate – a cast slab of concrete is placed and levelled – the bubble balances – there are three holes – one to accept drainage, one to accept the flowers, and one to accept the anchor, which is driven home with a 4 lb lump hammer – steel ringing beats in cold air, against oak branches, against the courses of ashlar.

The mason's beat. A driving beat. The sound of every hammer across time in unison. Same as it ever was – that letter-cutting rhythm – there was an old boy, Willy Hill, who would beat the lead into inscriptions as though he were ringing a bell.

The younger man brings water from the churchyard tap and the older man spoons out cement onto a battered metal dish, quenching the powder from an old yellow sponge. Painful cold to the touch – in the warmer months they could take a bit more time, admire their surroundings, but after the gobbo is mixed it turns quick.

The slab receives cement in splats – the young man fetches the base from the van, sack barrow squeaking, a slight wobble – the tyres are vulnerable to thorns. The base is tapped into position, joints pointed, cleaned – they both fetch the headstone – big job – Purbeck, full of thin submarine fossils – sandblasted lettering but the decoration is hand cut – ears of barley, the disc of the sun – epitaph – a kind and gentle man.

They don't think about moving it, it just happens – the method more or less the same for centuries, longer – a wee lift – a wooden roller – roll under, roll, lift – slide down the barrow, resting the steel dowels on the footplate, then gently to the grave – they've done it a thousand times but the old man is getting slower, you can tell in the knuckles, in the wince when he bends – he tried retiring at seventy but, y'know, it wasn't easy after she died. That last couple of years have whittled him into kindling.

The rest of the procedure is textbook stuff – to me, to you – line up the dowels in the bottom of the headstone with the holes in the base – cement, pivot, lift, in – clean the joints. Same as it ever was.

They both stand, tidy the edges, swill away dirty water – clearing the trauma of their boots around the graveside – leave no trace, only headstones – younger man fashions a rollie of Samson and fetches the aluminium flower pot – older man squirts a little WD40 on his knuckles and wrists, says it helps with the pain.

Look – in the milky clouds east, a sun dog forming, just. Crows.

Another two to do this morning. Binbrook, then Scartho. The van radio comes to life as ignition is made – BBC local radio – mid-song Moody Blues – that rusty Mellotron – late-winter morning light.

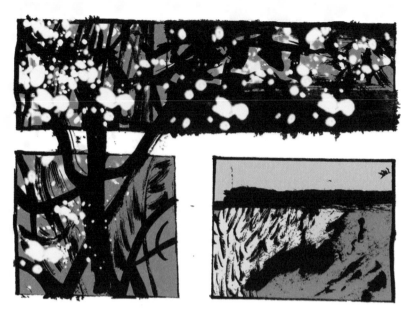
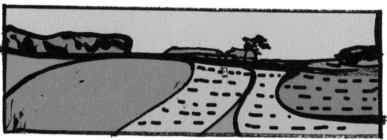
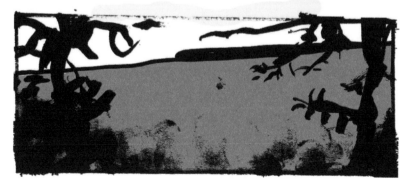

April

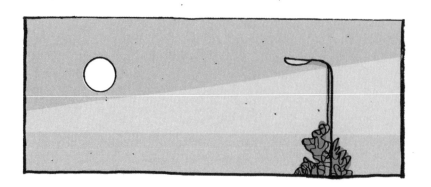

4/4 – curlew ratio strong – thirty-two at least – a morning near Doggerland, then trying to get some sleep before work later – children cut through the dunes and poke about at debris in the strandline – wife making notes for poetry and looks majestic with the glitter of the Great Eau all about her – standing on a pillbox hurling tennis balls for the dog.

10/4 – the triumph of spring – the redoubt of blackthorn that rings the scrubby patch, frothing with blossom – spent a long time in it – walked down the Grayfleet and pulled a lovely chert lump out the water – a keeper – a rucksack-sized replica of Phobos.

15/4 – green paint accident – oilseed very much out – maximum cadmium yellow and a flat grey sky – the A18 to elsewhere, *Autobahn* on.

27/4 – Kurosawa rain – a heron at the edge of Solaby – a plastic dinosaur at a scrapyard gate – honesty-box duck eggs and chutney – Nissen huts where the Italians from the Desert War slept – popular dogging spot – there's a pamphlet to be made – Laybys of the Outmarsh.

–

Another green dawn – sun out east low – a bowl of tomato soup on a canteen table – slate-grey funk of wet sky, the greens are really green, a flash of yellow strikes through the haar – wood pigeon sonics, that slow cassette fuzz of late-spring sunrise – the murk will burn off later but it won't matter much – the valley is always cool anyway – a microclimate – a tributary twists in the belowness of it, one of those chalk streams the agencies monitor.

Look – big wood/mixed deciduous, old feeling.

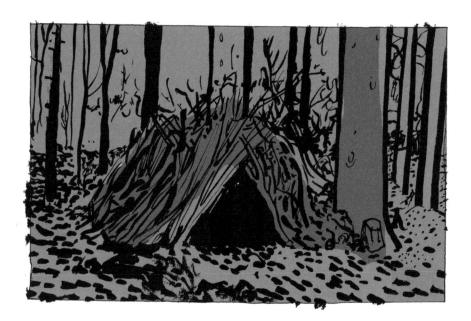

The ruins of a whalebone arch erected by Victorian men of wealth – two crumbling ribs, green in the dampness, the marrow exposed and mossy – what oceans did this beast swim?

Pigeon ambient/pheasant electronica/whirring sound under big feathered breast – usual woodland birds – keepers keep pheasants up the north end for the big house – a bench in dedication POACHER TURNED GAMEKEEPER – nets and enclosures, bags of feed with an orange circle on – Danny, Champion. Men pay good money to come, to feel what hunters feel.

Path down in the bottom – wet – all the water from the plateau drains down through chalk and flint, makes the valley green and thick.

Scramble the left banks – there's a safe place, out of eyeshot, unseeable from below – a good place to spend the night, Ray Mears

style – under something army surplus, perhaps – Warsaw Pact canvas? Copy of *Rogue Male* to hand? Lovely stuff.

Settle in for a long night, couple of tins on the go, something easy to cook. Noodles – the cheapest are best – early cautiousness fades with a nip or two – keep the fire small/tidy – if it burns hot there will be no smoke, just enough heat for company – the light of a fire in the woods is its own cinema – the best, really – but it's getting harder to get out – fewer places off charts, fewer places out of sight.

A schoolboy found a flint down here – an old one – from the deep times.

Over the years other stuff turned up – a chert axe – scrapers, blades, pokers, hook – tools to butcher, tools for meat – someone was cutting flesh here in the way back – deep time – before the ice and when the game was good. How does that old song go? Two big horns and a woolly jaw – a flint-tipped spear plunging into the neck, hard, from above – throat – a Hammer gush – kill shot – good aim, kid, good aim. Found a book in the library sale about the geology of it – of here.

Look – the language is concrete – fallen off the edge of the academic into deep poetry.

Lincolnshire Wolds

Ooliths, exposure + fracture

From Kelstern plateau –

BRITISH

GEOLOGICAL

SURVEY

The unconformity – frost action may be invoked with the passing of the ice wedge.

Flinty gravels – red deer – tusk – chalk-horse bone, tooth of a ghost mammoth.

The unconformity, older drift, newer drift.

Words spelled out with the weight of the glaciers behind them – read it out with Mark E. Smith in mind –

The unconformity, older drift, British Geological Mammoth Time.

Look – sun now high enough to beam light through the upper canopy – lime and limpid green projections/limbs in shadow/vapours – green as Arthurian – green as *Excalibur* when broadcast on the old telly, 21 August 1994, BBC2, 10.20 p.m. – Alex Cox.

Two big crows – motor drawl – tarmac hum – the Lincoln road isn't far – engine ticking over.

Keepers at their keeping. Grain feed in blue barrel feed springs.

Fatten up – same place/20,000 years ago – fatten up – geography makes for natural kill zone – those steep sides funnel the big beasts in – fat bulls and cows – a staggering calf or two – weak, delicious.

Take the higher ground – an unseeable spot above the beasts – use the weight of the flint with the energy of the chuck.

Imagine it, the proceeds – tusk sleds topped with bolts of mammoth felt and rendered fat – Paleo-Joseph Beuys without the hat – laying the energy plan for Western man.

The slaughter and processing would have been a big deal – make a day or two of it – shout the neighbours over from the next valley with a tune from the bone flute – various dishes and preparations made – the joints best for roasting – strips of jerky – tallow, sinew, guts – nothing wasted – social stuff, bit o' trade and that.

Look – sausages – there would be charcuterie, early hams – strung to smoke by the fire – keeps better for the lean times ahead – the high fat content makes it easy to slice with a stone razor.

Once the marrow has been sucked clear out of obscure bones, a fife is whittled for next time.

It was deep time, that javelin hit.

Grid reference TF28278835 or thereabouts.

Findings – May 1970. Massive flint gravel unit of Upper Gravel with iron and manganese oxides, enclosing antler tine of red deer (*Cervus elaphus*).

There's an exposed and quarried face at one end of the valley – strata over strata, whittled back to the nerves of earth – a dark, even band in the chalks and cherts – some global-catastrophe stain from before memories.

Look – two runners pass with swiftness and sweat through the mud to the exposed edge of once-quarried chalk.

May

9/5 – warm enough for the first disposable barbeques – back garden cider, four tins for £2 – two doors down, Tim the tyre man has begun grilling chicken outside and the smell lingers – elsewhere, a nature writer has turned stationer, selling quaint notepads to weekend pagans.

10/5 – young nettles rampant, that tang in the air – good – the garlic is up on Dark Lane – in those woods was a caravan full of arrows and survival grub – have you ever seen *Southern Comfort?* – sent mammoth tusk drawings to the doc.

21/5 – too many nights – half cut on exhaustion – around the reservoir singing 'Pacific Ocean Blue' – later, the geological paintings of E. Jude.

31/5 – lightning across the eastern horizon – the beacons on the turbines casting signals through the fog – repeat, relay – the tarred post of the beacon – Fire Over England.

–

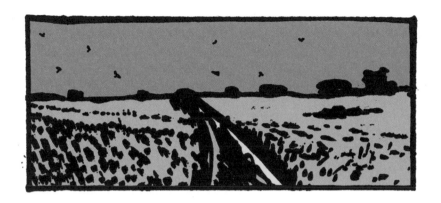

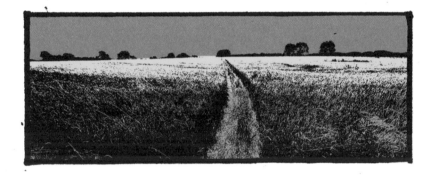

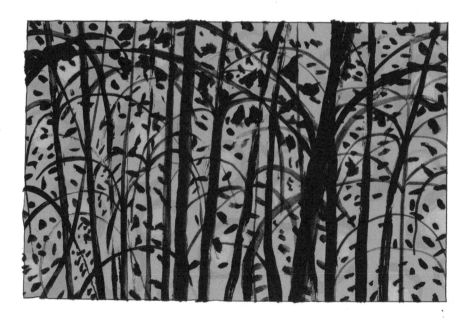

Out in the early heat – long grass of the field that never got cut – better than fallow – derelict turning to nature reserve. Red Admiral action – clumsy cocoon-drunk flutters. What time is it? The sun is hot enough to burn – what time is it? – would that Flava Flav were here – a man with sandals and shorts carries a wounded toddler.

Kids have been out – sports litter – cock drawn on the pole of floodlight – gushing, old god.

The field has a cut-through – unofficial track, secret path – but appears on older maps – OS 1888, a dotted line, see – this has always been a way – shortcut – snogging patch – dog run.

Look – in the summer months there is a fellow who sleeps in the hedge – not romantically, not bushcraftly – he's on black mamba most of the time – dogs will come and smell him out – sometimes he stands out the back of the evangelical tabernacle as if he were Alice Cooper in *Prince of Darkness*. Sometimes he comes to hear them sing – not a bad lad, just lost, fading.

The grass was last cut seven or eight years ago – you can go full Richard Long here if you must, and walk your lines and make your land art – the grasses are strong here – bristle-thick, pike-deep.

Older kid – shortcut – Minecraft T-shirt – blue drink.

The index of grasses –

Hiroshige rain

East German camo – the splinter stuff

Cinematic arrow motion – the Olivier stuff

Yorkshire fog – *Holcus lanatus*

The limbs of allied harvestmen scutter blade to blade.

There's a heap of apple wood that appeared during the last cut – stacked up for bonfire, never burned – now the nettles swell above it and the wood is black from weather and rot. The pile is full of spiders, covered in webs. Inside there will be rats.

Look – the field does strange things – on wet mornings it hangs, green and lungish and ambient – imagine the stalker cutting through under the telegraph pole that leads to nothing – the stirrups are unclimbed and the wire loose enough to ripple in a breeze.

Found a note here once – under the wire –

'Please God let me live a righteous life' – blue biro – A5 notepad, torn at the wire spiral – holding it up in the light you could see the letters from other pages – just shopping lists, by the looks of it.

A half path in brambles and blackthorn, brick underfoot, a decaying shed exploding slowly from within due to the growth of an apple tree – someone is always looking for planning permission.

Across the sky the vapour trails west to east – transatlantic flights heading into Amsterdam, Frankfurt, beyond.

In the wintering months 40,000 pink-footed geese will wing from the other direction and the gulls will glide back to Humber on the last day's thermals – watching the birds come in the dead grass of the scrubby patch.

There's a house at one edge of the field – a drive that acts as a cut between field and pavement – look – the gravel drives of semi-detached houses are rich in the calcified tendrils of crinoids. On clear mornings that bloke stands by the chapel.

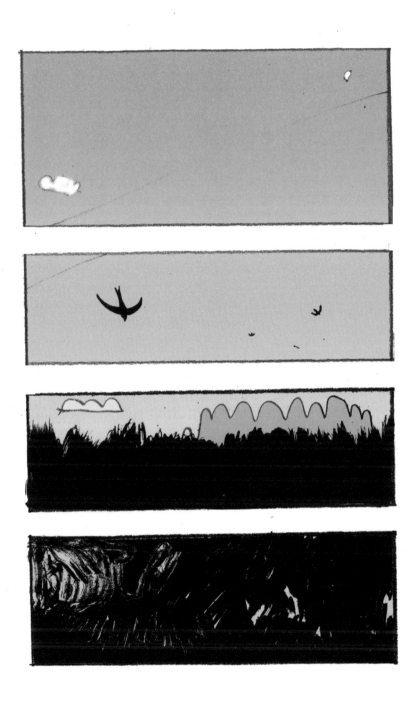

June

1/6 – ladybird summer – passed the chip golem – car boot at the New Inn – bought Bowie cassettes off a man on oxygen who didn't have long – other stalls – foot spa – rusty blowtorch man – 10p action-figure selection – surplus gear, fishing tackle, books on Axis camouflage – white van selling tins of pop by the slab.

18/6 – up the Twisties – no map calls it the Twisties – a few people call it Tramp's Point but they are wrong – the old railway line is as close as you'd get to a holloway – deeper on there are traces of the local hunt – kegs and hoof marks – one winter they came out in hundreds – red, steaming cavalry.

21/6 – the centre of it all – working through the shortest night – the brightness doesn't really fade – it's hot, the night is hectic – NEOWISE is clear toward the east, then the ISS passes, brilliant again.

27/6 – thick heat – feet in the Bain by the deserted medieval village – an oak has grown around barbed wire – dormant church surrounded by a cluster of ash, yew and oak – a shaded place – deep nettles, everything smells very green – the door is locked – by it is a carving, medieval woman, late teens, early twenties, she's beautiful, tiny bits of shell in the stone of her pupils – three older grotesques, gritstone – a tiny bird leaves the nostril of the furthest.

–

Walking hard in ochre lines through wheat and along tracks between farms – a trace of moon left and little birds on the wires – summertime in England.

Look – a restored Spitfire is put through its paces – a green lane with wild garlic – a straight line south for miles – it's good going, cool

under oaks and ashes – poppies in full colour – a stand of pine trees a little way off toward the sweep of a wide and low valley.

Look – almost Napoleonic, certainly Ivan Shishkin – the clouds are perfect – three quarters of a brick barn and the foundations of a bonfire heap – quick poke reveals the wrapping of a branded pastry from Cornwall – Chicken and Mushroom Slice – best before two winters ago – and a rat-chewed pipe of Pringles – Sour Cream and Chive – the volume of grasshoppers makes the air shimmer – at a junction of tracks is a handmade sign.

Look – NO WALKERS – beyond the sign is a copse, chalk pit within – a deep, wet place, a green place – no obvious reason as to why it is forbidden – just a few shotgun shells – on, another junction leading to another copse – consult the old map – Flint Hill House – long gone, a fire caused by lightning – 1916, according to the local historian, days after the eldest son bought it at the Somme.

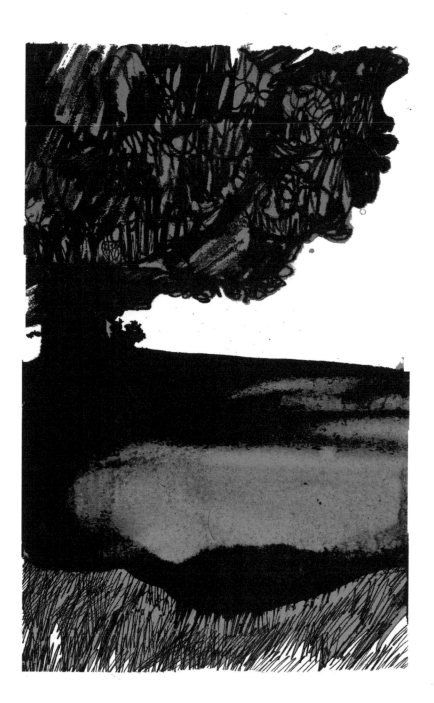

July

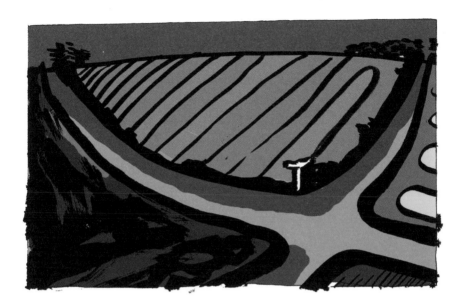

4/7 – walk to night shift – the evening is warm, the short nights still hanging – the comet will be visible later – overhead, closer, aircraft descend to approach Doncaster.

10/7 – walk to night shift – 21:19 – from elsewhere, voices – chicken on charcoal, music, present but out of range – bats feeding in the vortex of greenfly – two young people walking west, very much in love – eighteen, nineteen maybe.

11/7 – night off – drawing telegraph poles, windows open – mason bees come in and out – summer dresses, over-the-fence chunter – later – gulls drifting on the warm air to Humber – drawing the fallen sun, little crosses for birds, ghost mammoth.

25/7 – walk to night shift – 21:18 – the sound of breaking glass – grey bins are out – night returning inch by inch – one of those big-bulbed garden spiders at work with silk under the streetlight.

–

Night shift has been heavy for months now – almost psychedelically exhausting – the world turned upside down.

Look – on the way in there is a concrete bridge that overlooks the Lud. A good place for a few moments' quiet before the storm. There's a ruler to the left connected to a flood alarm, just in case – it's happened before.

Next to the bridge is a former mill that in older days produced Three Crowns flour – it's flats now. During the summer this stretch of river is gin-clear, rich in crowsfoot and invasive crayfish. There are 1 billion midges. Bats feed in great circles of attack over the surface of the water.

Look – the western sky at 21:18 a month after midsummer – the bridge is a good place to lean as the sun sets. A football floats on the current. There are trout and rats – a man who lives downriver says he saw an albino otter – sometimes there are kingfishers and a heron comes here and in '43 two Royalists were killed running from the Ironsides.

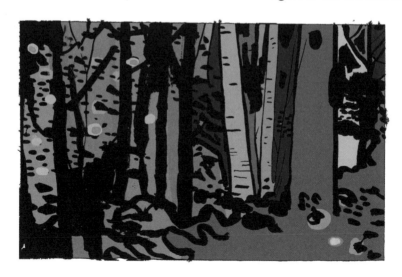

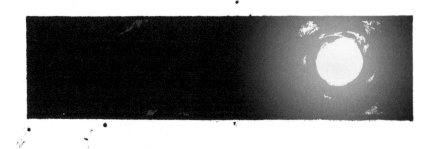

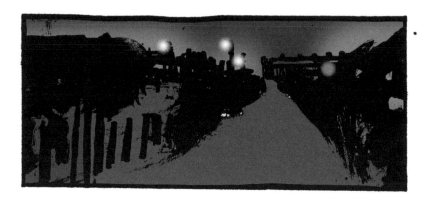

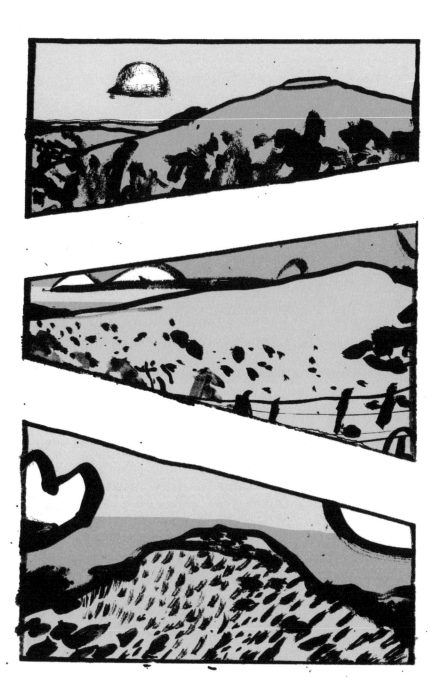

August

6/8 – at a barrow – soft weather – the grasses catalogue is delicate, rude even – the dog days are here – within the mound are various traces – a fistful of earth, a life lived way before the years of the Christ, before Alexander wept at the breadth of his domain – walking back through town – grilled-meat smells – the perfect confusion of teenagers on Dark Fruit, drifting back from Hubbard's Hills via the Spar, cussing Big Simon, who won't serve them.

15/8 – walking over baked-clay fields – chalk dust – a path through large fields – deep crop (oilseed) – assorted flint (not worked, flake maybe), pot shards, pipe part, ring-pull (modern era) – forced through a deep hedge into a new build where no one was about – filled up on water in the yard.

22/8 – first rain since early July – hot and heavy then breaking from the southwest – black, looming afternoon – thunder and downpours – all the frogs came out of hiding – big lightning – a letter from Uncle Werner.

27/8 – walk to night shift – slowly into autumn – trout still in the river, flicking about, trout-style – kid on a bike shouts something – lawnmower ambient – somewhere, that raging glory.

–

Look – Cow Pastures – a patch of trees that occupies the horizon west of town – these woods just beyond the bypass are a fortress to some – the embankments of the ring road make a fine redoubt – the blokes who play airsoft up here even dug slip trenches and foxholes between the trees.

On Sundays a burger van pulls up in the layby and does a good business in sausage buns and Styrofoam coffee. Hillforts aren't a thing around here, so this will have to do. In the war there was a Bofors

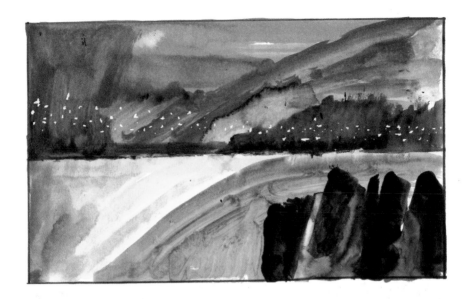

gun and two searchlights up here – took down a Junkers that ploughed into the hill face first – after the fire died down and the scrap men took the plane away, someone found a load of pottery beneath the crash – couple of years later Kenneth Winstanley came up from Hookland to sniff around the local barrows. He was a one. Nephew of C. L. Nolan – pulled up 200-odd Saxon cremation urns right where the bomber had gone down – not a trace of the Junkers, mind. Those poor boys.

Look – at the back of the wood is a nylon rope everyone said was left from a suicide – have a swing – dare ya – townies would go there to snog goths in secret and at least once there was a report in the local paper of devil worship – some places just gather rumour – Fotherby Common – you just don't go to Fotherby Common after dark.

Cow Pastures hangs over this landscape, an eastern Wittenham Clumps but better and darker – there's a hill outside Bath, up beyond

Weston, dominates the approaches from Bristol – used to walk up there on Sundays with a woman called Joanna. Used to climb up Solsbury too and see to Phil the Gardener's flat on Snow Hill – no eagles.

Look – Cow Pastures, and not a real name either – the real name of this place is Skeleton Hill, look on the early OS maps and there it is – nothing good ever happened on a hill named Skeleton except snogs with goths.

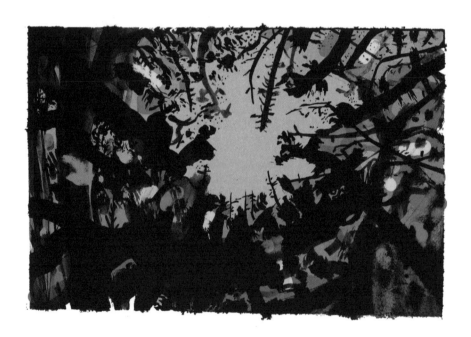

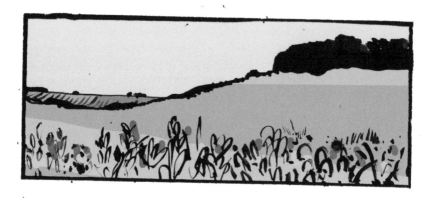

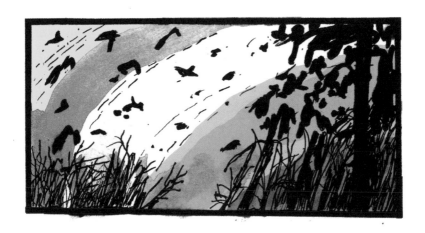

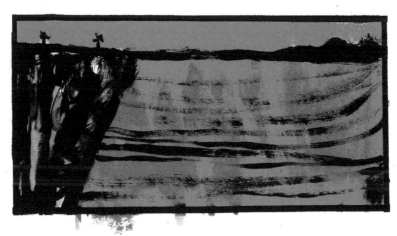

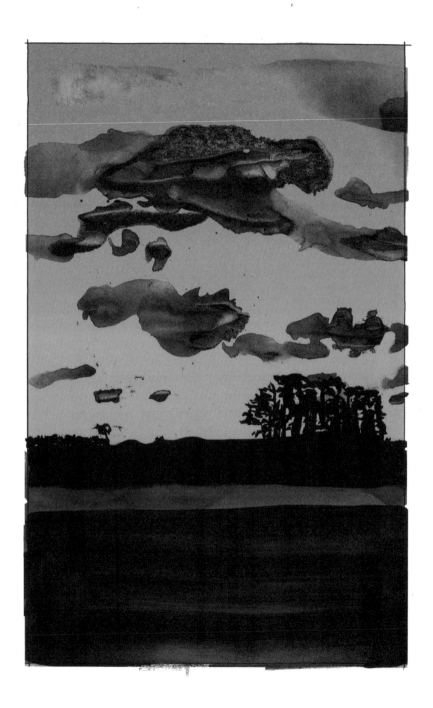

September

1/9 – after work, half seven – up through the long grass – on the old telegraph pole, a planning proposal – eighteen executive houses – it floods here in wet winters and in 1890 a fella found a bit of tusk – eighteen executive houses to be built on ghost mammoth, should be fine – the border of the field is thick with brambles, long thorns – good picking – beyond that are floodlights, five-a-side pitch ramps and the Mayfair Club.

13/9 – over the horizon, the first flush of sun proper, a sudden key change – spider time across the scrubby patches, full of endless webs – Typhoons heading out toward the North Sea – in the deeper above, the Washington to Amsterdam has thirty minutes' flight time left and casts the light of morning in the trails behind it.

29/9 – Turner was right.

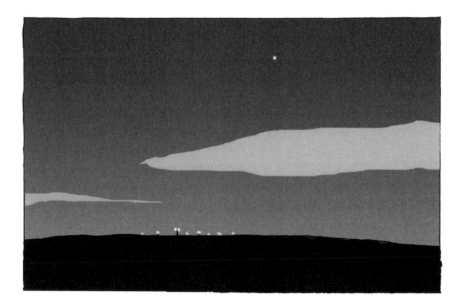

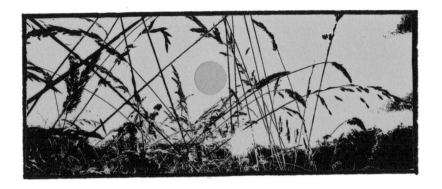

27/9 – a badger walks down the pavement at midnight and visits the bins at the back of the Co-op.

–

Early – still under astronomical twilight – the glare of stars that may already be dead – there's an owl near the allotments observing the vermin among the last of the blackberries – on the tower at the Holy Trinity, pigeons dream – a spider in the railings, web with midges, wing pieces.

Look – the sky is herringboned, a ground mist rolling in around the lower geography – across the outer east, colour is returning – an atomic blush – the entire history of landscape painting – luminism, gulls – walking out along the navigation, past the iron bridge with Zimbabwe written on it in thick-brushed letters – past the hanging place.

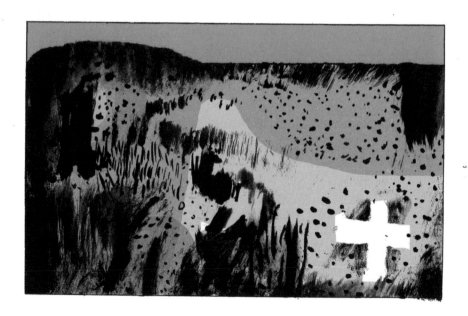

Look – out along the ruined locks a bloke is out waiting for a kingfisher, a heron, an egret or two – he is writing a book of local ornithology and has a flask of milky coffee – there are two women running back in the direction of town, making vapour trails.

A helicopter, blue and red livery, flies north to south, a pick-up near Norwich then out to Triton Knoll, where wind is farmed – a telegraph line of starlings, no murmuration but they are considering it – skirting the edge of a village, detached house of the 1980s, BMW.

Look – brighter – mackerel sky reflecting cadmium yellow – the final stars, the monolith blast of Venus, diamond hard against Prussian blue, a sheriff's badge at the end of the night – cross a farmyard illicitly at 5:37 a.m. – earthworks of uncertain origin – a fortress of leylandii conceals battery sheds, floodlights casting long shadows – somewhere close is the voice of local radio – Moody Blues, a rusty Mellotron, Partridge banter.

Look – a magenta stripe, briefly, a single, confident application of the correct hue – it bleeds into the building clouds and fades – the surface of the Grayfleet dyke is black with an oily film – something dead with sticky feathers – footsore, colour draining out of the sky – headphones – Brothers of Darkness, Sons of Light – look – jackdaws.

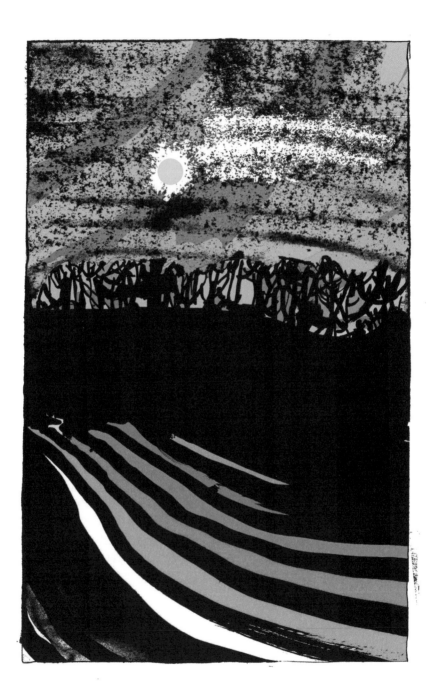

October

6/10 – a field in England – a paperback of Welsh poetry with a cover by Stephen Russ – drawing horizons, making idols out of chert and Milliput – looking at the oceans of the moon with a skinful of cooking lager.

14/10 – made a bow for garden kicks, taking out empties with cane arrows and building a fire, whittling sticks into kindling with a killer billhook – the crackle of old fence bits, a sausage on a stick – a man from the allotments peeks over, has a chuckle.

15/10 – walk to night shift – the stars on one – firepower coming in low to Donna Nook – geese against them – Orion – the concrete bridge is caked in woodlice, again.

22/10 – making drawings of the territory in the morning, keeping the energy keen through the nights – making paintings for the geologists – writing passages on the electric iron age, stellar death – plodding on.

–

Boards of Canada weather – the weirdness set now – battered, pewter October turning toward November – Christmas in the supermarkets – allied harvestmen, again.

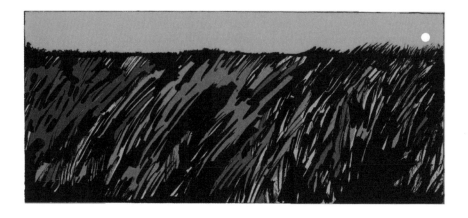

Look – flickering gull – jet fuel – in sense of space – the distance between treeline, telegraph pole, vapour trail, rook, pram – danger at the edge of town/weird debris – everyday impact events – litter, shits, excavations, coughs.

Look – a hand-ground lens fashioned to focus on the moons of Jupiter – *Nosferatu* '79 energy – solid weather with gulls.

Look – Mearcstapa/notorious boundary walker – *Future Days* – settling back into pillbox life, an island spell – hold fast through the nights.

Look – under Betelgeuse, Rigel, under Bellatrix – the names of other suns – Jupiter closing in on Saturn – the Plough comes up heavy over the north – handle pointing toward Spurn – night rolls on – attack craft on manoeuvres – low with afterburners – sky grinding – Venus will ride the morning.

Later – acid green and mace spikes of sun – battery farm, wind farm, a leaning church.

Terminal Road – three bungalows by the dyke – car full of children – Dylan '66 on – electric, Free Trade Hall – Number 1, Achilles – Number 3, Sea Shadow – a yard of black-sacked silage bales, tyre tracks, part of a decaying Nissen hut from when the prisoners of the Desert War were shipped out here.

A pillbox – three-bay job facing the remains of a house slowly exploding with ash trees – later – the old map reveals the house was a pub – the Ship Inn – there's a photograph – two Tommies by the ditch, early summer by the look of the trees. Wood pigeons purring – another time, another place.

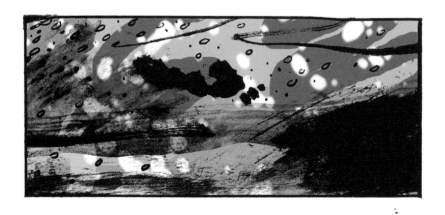

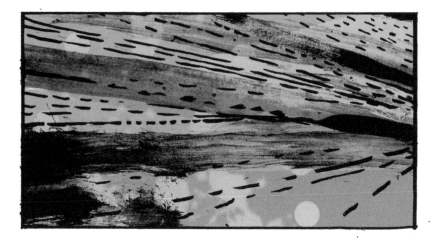

From over the hills, a Chinook heading to the ranges – didn't think they'd be out this time of winter, not when the seals are in.

Going east – easter – eastest – to the lowest point – out where the forests began – a familiar route through familiar villages – Manby, Solaby, Solaby St Peter, Solaby St Clement.

Sign – FREE MANURE – sign – Eggs £1.20 – and electric-wired field with a white horse and a small boat – on the side of the boat is a telephone number.

Look – heavy weather building to the north – curlew ratio up to twenty-seven – the car park is empty – burning fog coming in off the near sea fields – a 5p sun – through the buckthorns to the intertidal zone – little orange berries – blackness in the sky beyond the waiting tankers – wave crowns going sideways – head north – a bloke with two dogs, a short g'morning – a spine in the tide scum and cut timber of some age, massive nails deep in the grain – north still – quick fog at low level with sun cutting over the upper limits – beams hitting the sea – spectrum in the spray – north – snow tower clouds over Humber dropping down to a slate-grey scree heading in – forty-two geese in skein from the Winglands – the speeding breath of them all Beefheart – rain shifting through murk then sunlight – dirty marram, no rabbits – jackdaws on the spit with the pillbox, spiders in the reeds, the Chicago to Amsterdam above it all, gleaming.

It's been here for years, the tank – an A34, a Comet – saw action outside of Berlin – got scrapped, eventually, and used for target practice when the ranges extended this way.

The turret of the Comet got blown off in the fifties – the body is still pretty solid – plate steel, thick welding that never took to rust –

stumps of the shock absorbers, teeth of the gun gears, driver's portal looks toward Saltfleet and beyond.

Look – murk clearing – rain moved west – dead jellyfish.

Something glitters and flaps at the waterline – too silver for a seal – saltwater remains where the sea just was. Tiny islands of old samphire, tiny crabs waiting to be taken back – other than that – sheer flatness – walking under the borderline of clouds, cirrocumulus, altostratus, cumulonimbus.

Barely a division between land and sea – walking in the mirror zone, walking a palindrome – geese on the wing.

At the border of the water and the sand there is no mirror – what is that? there – something in the surf – a mirage? Wouldn't be the first time the light has played games out here – a silver lump in the waves – closer.

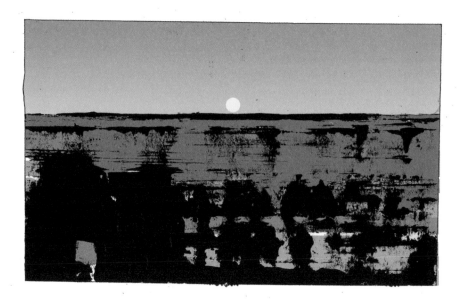

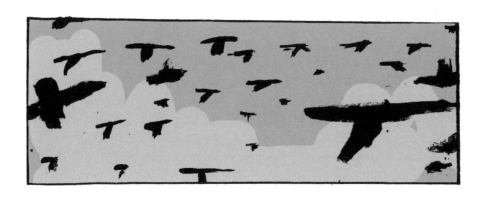

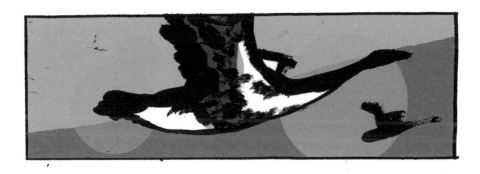

There in the foam, a half-bloated, half-inflated balloon – silver – double-sided – two-faced.

Olaf the Snowman from *Frozen*.

Look – his inert eyes, east and west – the Romans called him Janus – the god of boundary, edges, day and night, thresholds, duality, beginnings and endings – his abode and the limits of Earth and the extremity of Heaven, in mirrors.

Janus washed up from Doggerland – son of Apollo, son of the sun.

His head full of helium, the body weighed down by the North Sea and slurry and a tangle of blue rope guts spills from him – somewhere, a child must have held it – then let it go.

Look – around – the sun burning murk into halo light – a line drawn by the hulk of a bull seal – a line drawn by a jet from horizon to horizon – a line drawn along the belly of the ghost mammoth with a knife made of stone.

The spirit level – another threshold – always different, always the same – to me, to you –

ONWARD

Acknowledgements

With thanks to – Simon Spanton – Jeff Barrett and all at Caught by the River – Gareth E. Rees and Gary Budden – Spaceship Mark Williamson – Simon Moreton – Dr Eamonn Griffin – Hand of Stabs – the Roberts – W. H. – Caroline Bingham – Mr Paul Osborne – Kurt Schwitters – the photographer Sarah Farrell – P. V. Glob – the Pikes – Robert Wyatt – the Cooks of Cumbria – Alexander J. Cartmell – the painter Michael Simpson – D. W. – Mr Drax – Mila, Łukasz and the Manchester wing – Derek and Carole, Paddy, Kevin, Cybil – Henry – Bill, Arthur, Rufus, John – Tim Dee – David Southwell – Paul Watson – Michael Smith – the mysterious geologist – our pal Pieter Bruegel the Elder – the Memory Band – Zali and Phoenix – Alia – Mr Jones – the bog doctors, the mammoth doctors, the flint knapper and the antiquarian – Harpham, Simon, Amanda, Kenny, Jen, Emily, Adam, Karen, Anna, Abel – Mark Ecob – Alexander Eccles – Banjo and the award-winning poet Fee Griffin x

A Note on the Author

Maxim Peter Griffin is an artist, illustrator and writer who lives and works in the east of Lincolnshire.

Unbound is the world's first crowdfunding publisher, established in 2011.

We believe that wonderful things can happen when you clear a path for people who share a passion. That's why we've built a platform that brings together readers and authors to crowdfund books they believe in – and give fresh ideas that don't fit the traditional mould the chance they deserve.

This book is in your hands because readers made it possible. Everyone who pledged their support is listed below. Join them by visiting unbound.com and supporting a book today.

Susan Adsett

Tanya Akrofi

Angie Allen

Simon Allen

Tim Allen

Helen Allison

Lulu Allison

Gary Allport

Matt Alofs

John Altringham

Sergio Amadori

Adrianna Amari

Frances Ambler

Inga Andersen

Nathaniel C R Anderson

Richard Andrews

Rob Annable

Joe Archer

Nathan Archer

Clare Archibald

Julie Arnold

Tim Arnold

Ceri Ashcroft

Will Ashon

Marion Ashton

Jean Atkin

Carly Attridge

Ben Austwick

Lucy Avery

Nick Avery

Jane Babb

Liz Babb

Kieron Bacon

Anna Badcock

Brian Baker

Harry Baker

Phil Ball

Martyn Barber

Roger Barberis

Alexander Barbour

James Barclay

Louise Barker

Phil Barker

Sara Barratt

Fraser Barrett

Christine Bartram

Jackie Bates

Adam Baylis-West

Emma Bayliss

Jacob Bazar

Finnian Beazlie

Dwayne Bell

Gareth Bellamy

Francis Bemrose

Noah Berman

Jess Bier

June Bingham

Tim Bird

Guy Birkin

Steve Birt

Susan Bittker

Graham Blenkin

Nathalie Boisard-Beudin

Bones

Owen Booth

David Borthwick

Brian Boucher

Matt Bower

Mark Bowsher

Stewart Brady

Jonathan Bridge

Alken Brookes

Kenneth Brophy

Annie Brosnan

Duncan Brown

Nadine Brown

Brian Browne

David Bruce

Christopher Buckley

Gary Budden

Dawn Buie

Marc Burden

Karen Burkhardt

Lazlo Burns

Paulette Burns

Luke Burstow

Ravi Butalia

Mike Butcher

Mike Calder

Neil Campbell

Olivia Canham

David Canning

Angus Carlyle

Victor Carman

Sean Carroll

Elizabeth Case

Shawn Casey

Barbara Chamberlin

Sue Chapman

Aliki Chapple

Ilona Chavasse

Paul Cheney

Nicola Chester

Annie Cholewa

Michael Chominski

Rachel Clack

Adrian Clark

John Clark

Louise Clarke

Roger Clarke

Neil Clasper

Jim Clayton

Mathew Clayton

Alan Cleaver

Paul M Cobb

Stevyn Colgan

Dominic Collier

Jamie Collinson

Dom Conlon

Courtney Connolly

Wendy Cook

David Cooper

Fi Cooper

Brett Corden

Andrew Cornes

Amanda Corp

Andrew Cotterill

J Covault

Barry Cowperthwaite

Dan Coxon

Matthew Craven

Jane Crawshaw

Peter Creber

Jamie Crofts

Alasdair Cross

Julia Croyden

Simon Cudlip

Chloe Cumming

Chris Curione

Benjamin Cusden

Nic Dafis

Juliette Dalitz

Kim Davies

Tim Daw

Sue Dawson

Chris de Coulon Berthoud

Rachael de Moravia

Gabriele de Seta

Sarah Deakin

Christopher Dean

Tim Dee

Mary Delaney

Jamie Delano

Andy Delmege

Philippe Demeur

Moira Dennison

Kate Devlin

Phil Dickinson (Mere Pseud)

Thomas Docker

Les Dodd

Dave Donnelly

Maura Dooley

Ben Doran

Christian Doubble

Dominic Dransfield

Tom Duckers

Lewis Duffy

Val Duskin

Tom Duxbury

Mick Ebbs

Naomi Ecob

Andrew Edman

Jean Edwards

Elena

Mike Efstathiou

Shawn Eisenach

Brian Elgort

Andy Emery

Elisabeth England

Nikki Espley

Cath Evans

Jack Evans

Phillip Evans

Tor Falcon

Stuart Farley

Sarah Farrell

Stein Farstadvoll

Virginia Fassnidge

Eric Fennessey

Courtenay Ferris

Wes Finch

Antony Firth

Russ Fischer

Nick Fisher

Sorella Fleer

Jayne Fletcher-Tomlinson

Nicholas Flynn

Tricia Fogarty

Jamie Forman

Mark Forrest

Chris Fosten

Sabine Foster

Mike Fowler

Marnie Frances

Mary Frances

Sara Freeman

Kim French

Ed Freyfogle

Mirjam Friebe

Melinda Fries

Katie Fuller

Martin Fuller

Michael Gallacher

Owen Garling

Ben Gearey

Mary Gearey

Amro Gebreel

Josie George

Andrew Gibson

Matthew Gilbert

Michael Gipson

Richard Glet

Niall Glynn

Susan Godfrey

Shirley Godwin

Nicola Goldsmith

Carl Goldspink

Giles Goodland

Molly Goodman

Paul Gorman

Susanna Gorst

Emma Graney

Emma Gransden

Rebecca Gransden

Annie Grant

Julian Grant

Sue Greaney

Caitlin Green

Philip Green

Helen Gregory

Jenny Gregory

Carole Griffin

Derek Griffin

Eamonn Griffin

F & The Boys Griffin

Paddy Griffin

Kevin Griffiths

Richard Grove

Natalie Guest

Stephen Guest

Carey Gustard

Keith Hackwood

Christopher Hadley

Luke Hagstrom

David Hall

Jane Hall

Peter Hall

Richard Hall

Steve Hall

Matthew Halliday

Sharon Halliday

Trish Halligan

R Halliwell

Jackie Hamilton

Catherine Hamp

Toby Hampton

Paul Hancock

Mat Handley

Jeremy Hanks

Aidan Hanratty

Liane Hard

Chris Harley

Hilary Harley

Norman Harries

Andrea Harris

Claire R E Harris

David Harris

Ian Harris

Oliver Harris

Sue Harrison

James Harvey

Robert Harvey

Barry Hasler

Katherine Hawes

Maryanne Hawes

Laurence Hawkings

Martin Hayes

Peter Haynes

Rebecca Hearle

Jayne Heathcock

Rob Hedge

Di Heelas

Jason Heeley

Normandy Helmer

Richard Helyer

Caspar Henderson

Fiona Henderson

Nick Hennessey

Neil Henty

Damon Herd

Nicholas Herrmann

Mark Hewlett

Martin Hickman

Nick Hirst

Anne Hodgson

Amelia Hodsdon

John Hodson

Peter Hogan

Graham Holden
Kim Hollamby
Elizabeth Holland
Mike Holland
Hannah Hood
Justin Hopper
Howard Horner
Eric Horstman
Matt Houlbrook
Jo Howard
Jackie Howard-Birt
Dave Howarth
Richard Hughes
Simon Hughes
Brian Human
Daniel Hume
Shayne Husbands
Sarah Imrisek
Cat Ingrams
James Irvine
Oliver Ivory-Bray
Andy Jackson
Mick Jackson
Helena Jambor
Susan James
Ian Jarman
Mark Jay
Tom Jeffreys
Dan Jenkins

Ben Jenkinson
Tina Jennings
Susan Jensen
Simon Jerrome
John Jervis
Derek John
Jon
Zoë Johnson
Stephen Johnston
David Jones
Hollie Jones
Karen Jones
Martin Jones
Matt Jones
MiguelJonez Jones
Sue Jones
Rachel Jordan
Rolf Jordan
Christopher Josiffe
Mary Jowitt
Emma Theresa Jude
J Kampinga
Kaspar Kazil
Petr Kazil
Charlotte Keane
Alan Kelly
Carolyn Kelly
Dominic Kelly
Luke Kelly

Hilary Kemp

Matthew Kempson

Aidan Kendrick

Helen Kennedy

Aaron Kent

Bridget Khursheed

Dan Kieran

Jill Kieran

Maureen Kincaid Speller

Natasha Kindred

Jean Kinkead

Olaf Kirch

Jackie Kirkham

Dave Kirkwood

Al Kitching

James Kneale

Rob & Karen Knight

Mark Lacey

Eddie Ladd

Quintin Lake

Norma Laming

Felicity Lane

Gary Lang

Frag Last

Nell Latimer

Brian Lavelle

Duncan Lawie

Hannah Lawson

Jim Leary

Colin Ledwith

Russell Lee

Charles Leonard

Sandra Leonard

Nick Levene

Brian Lewis

Patrick Limb

Helen List

Mark Little

Tamasin Little

David Lloyd

Charlotte Lo

Vincent Loates

Angharad Lois

Kelly Loughlin

Amie Love

Yvonne Luke

Alice Lyall

Calum Macaulay

Andrew Macdonald

Gavin MacGregor

Fiona Mackenzie

Morven Macrae

Bridgid MacSeoin

Marianthi Makra

Keith Mantell

Losa Marl

Alison Marris

Heather Martin

Hannah Mathers

Ceri Matthews

Joanna Matthews

Rose Matthews

Steve Matthews

Claire Maw

Julia Maxted

Tim May

Lucy McCahon

Liza McCarron

Yvonne Carol McCombie

Shane McCorristine

Gavin McGregor

Frances McLaughlin

Kirsteen McNish

Ellen Mears

Lee Melin

Peter Merrett

Mark Merrifield

Will Merrow-Smith

Chloe Metson

Wendy Mewes

David L Miller

Toby Miller

Jeffrey Mills

Laurence Mitchell

Rob Mitchelmore

John Mitchinson

Diarmid Mogg

Brandon Monk

Richard Montagu

Matt Morden

Simon Moreton

Tony Morley

Stephen Morris

Colin Morrison

Jo Mortimer

Polly Mortimer

Gabriel Moshenska

Alison Munson

Jo Murgatroyd

Kevin Murphy

Tom Murphy

Kate Murray

Stuart Murray

Grug Muse

Nebolland

Fergal Nally

Carlo Navato

Nebolland

Matt Neil Hill

David Neill

David Nettleingham

Christopher J Newman

Ray Newman

Janice Nickolls

James Nightingale

Louise Norgate

Stefan North-Sagrott

Jens Notroff

Sarah Nottingham

Nigel Nunn

Linda O'Brien

Tim O'Leary

Mark O'Neill

Hannah O'Regan

Mick Oldham

Kay Orchison

Peter Orr

Angela Osborne

Mark Oswald-Cutler

Christopher A. Otto

Justin Owen

Scott Owen

Graeme Oxby

Chris Page

Di Page

Lev Parikian

David Parkes

Alan Parkinson

Dan Parkinson

Mark Parsons

Paula Patch

Moira Paternoster

Adam Ross Patterson

Jon Peachey

Melanie Peake

Alice Peasgood

Anibal Pella-Woo

Vicki Pepper

Richard Percy

Hugo Perks

Rebecca Perrett

David Petts

Brian Petyt

Neil Philip

Arthur Phillips

Het Phillips

Max Phillips

Philolithia Philolithia

Justin Pickard

Arabella Pike

Ben Pike

Olly Pike

James Pocklington

Justin Pollard

Tom Pollard

Matt Pope

Rosalind Pounder

Tracy Powell

John Power

Tom Poynton

Laura Pritchard

Ian Quann

Shannon Queen

Patrick Quigley

Sean Quigley

Mat Quine-Smith

Jeremy Radcliffe

Riana Rakotoarimanana

Filippo Ranieri

Ben Ranshaw

Myka Ransom

Chris Ratcliffe

Nick Reed

Gareth Rees

Nick Rees

Natasha Reynolds & Halil Sen

Electra Rhodes

David Richards

Neil Richards

Sioned-Mair Richards

Lorna Richardson

RJ Richardson

Lee Richardson Foster

Lucy Ridout

Darren Riley

Martin Riley

Christine Robbins

James Robbins

Andy Roberts

Dr Dafydd Roberts

Rachel Roberts

Tony Roberts

Patrick Robertshaw

Gareth Robinson

Justina Robson

Marilyn Roe

Ellen Rogers

Isaac Rose

Jilli Rose

HJ Rose-Innes

Dominic Rothwell

Henry Rothwell

Jon Rowett

Christopher Royston

Mark Ruddy

Alistair Rush

Simon Ryder

Hannah Sackett

Sam & Charlotte

Samantha & Thom

Tommy Samuel

Robert Sanders

Christopher Sanderson

Elizabeth Sargeantson

Kay Sauerteig

Yusef Sayed

Varsity Schitts

Güntzel Schmidt

Janette Schubert

Christian Schwägerl

Cavan Scott

Paul Scully

Jackie Scutt	Kevin Sommerville
Stephen Seabridge	Hattie Soper
Tony Sears aka Joe Strimmer	Nicholas Soucek
Mary Seaton	Rob Spencer
Belynda J. Shadoan	Ralph Sperring
Tanya Shadrick	Spriggs
Michael Shaun Ebbs	Wendy Staden
Chris Shaw	Tijmen Stam
Andrew Shilcock	Linda Steel
Katy Shircliff	Tristan Stephens
Joana Shishakly	Jan Stette
Jared Shurin	Alex Stevens
Greg Siegel	Jason Stewart
Stuart Silver	Terri Stewart Hackler
Claire and John Simon	Jeremy Stokes
Alan Sims	Brendan Stone
Chung Hua Siong	Mark Stone
James Skeffington	Nick Stone
Derek Skipworth	Simon Storey
AufKovacs Smith	Beth Stratford
Cathy Smith	Catherine Street
Heather Smith	Maria Strutz
Karen Smith	Susan Stuart
Michael Smith	Rich Sulley
MTA Smith	Alistair Sutton
Shelagh Smith	Christopher Sweetman
John Smyth	K Swire
Richard Smyth	Alan Tapster
Claire Solanki	Dougie Taylor

James Piers Taylor

Steve Taylor

Andy Temperley

Antonia Thomas

Matthew Thomas

Tim Thomas

Helen Thompson

Liz Thompson

Michael Thompson

Graham Thorpe

Marian Thorpe

Ellee Thunfeldt

Lee Thurston

Jonathan Timbers

Monica Timms

Adam Tinworth

Samuel Toogood

Stephen Toogood

Sabine Tötemeyer

Anni Tracy

Isabelle Tracy

Mark Treacher

Lindsay Trevarthen

Andrew Turnbull

Chris Turnbull & Mark Forbe

Derek Turner

Lewis Turner

Luke Turner

Bill & Aimee Tyas

Oliver Tyce

Ben Tye

Vangelis Tzanatos

Candace Uhlmeyer

Michael Upton

Roger Vaillancourt

John Vaillant

Andrea Kim Valdez

Marcel van Dasselaar

Maarten van der Werff

Kathleen Vaughan

Anna Vaught

Lee Vause

Biff Vernon

Joe Vernon

Nicole Vifian

Cat Vincent

Rhodri Viney

Birgitta von Krosigk

Catherine Vulliamy

Lisa Wakelam

Celia Walker

Sir Harold Walker

Stephen Walker

Michael Wallis

Valerie Wallis

David Walster

Josefin Wangel

Wendy Ward

Jodi Warrick

Wendy Wasman

Olivia Watchman

Iain Watson

Paul Watson

Jessica Webb

Tom Webb

Daniel Weir

Matthew Welton

Alexis West

Andrew West

Luke Weston

Katy Whitaker

Dylan White

Justine Whittern

Lynn Wiandt

Christiaan Wikkerink

William Wild

John Wilkinson

Phil Wilkinson

Rob Wilkinson

Alec Williams

Catherine Williams

Ian Williams

Javier Williams

Mark Williamson

Ursula Wills-Jones

Joan Wilson

John Wilson

Paul Wilson

Terri & Howard Windling-Gayton

Ann Winter

Heidi Wisenbaker

Howard Wix

Wolf of the Wisp

Alia Wood

David Gary Wood

Lucy Wood

Rebecca Wood

Martin Wood-Weatherill

Daz Woodcock

Steve Woodcock

Wulfgar The Bard

Jane Woollatt

Stephen Woolley

Nick Wright